Where the Meadowlark Sang

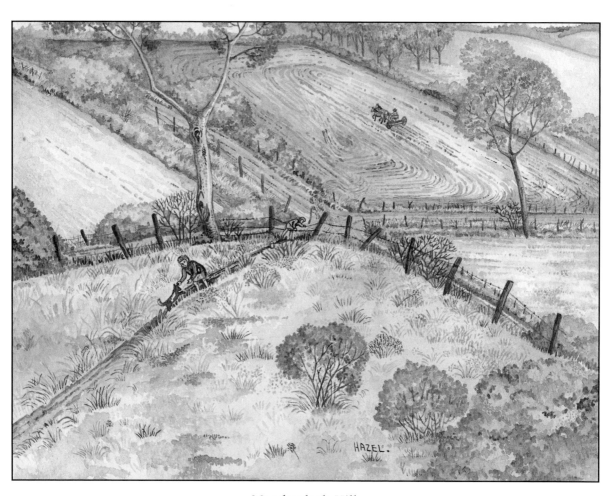

Meadowlark Hill

Where the Meadowlark Sang

CHERISHED SCENES FROM AN ARTIST'S CHILDHOOD

Hazel Litzgus

FIFTH
HOUSE

Cover and interior design by Articulate Eye
Edited by Lori Burwash
Proofread by Geri Rowlatt

The publisher gratefully acknowledges the support of The Canada Council for the Arts and the Department of Canadian Heritage. We acknowledge the financial support of the Government of Canada through the Book Publishing Industry Development Program (BPIDP) for our publishing activities.

Printed in Canada by Friesens

03 04 05 06 07 / 5 4 3 2 1

THE CANADA COUNCIL | LE CONSEIL DES ARTS
FOR THE ARTS | DU CANADA
SINCE 1957 | DEPUIS 1957

First published in the United States in 2003

National Library of Canada Cataloguing in Publication Data

Litzgus, Hazel, 1927-
 Where the meadowlark sang : cherished scenes from an artist's childhood / Hazel Litzgus.

 Includes index.
 ISBN 1-894856-09-0

 1. Farm life—Alberta—Pictorial works. 2. Farm life—Alberta—Anecdotes. 3. Litzgus, Hazel, 1927- —Childhood and youth. I. Title.
 ND249.L585A2 2003 971.23'0022'2 C2003-910031-6

FIFTH
HOUSE

Fifth House Ltd.
Fitzhenry & Whiteside
1511-1800 4 St. SW
Calgary, Alberta, Canada
T2S 2S5

1-800-387-9776
www.fitzhenry.ca

To my parents,
George Casselman Ball
and Isadora Emmaline Ball

Contents

Fall 33

Winter 49

Acknowledgements

I would like to thank my sisters, Jean Noyes, Kathleen Perry, and Mildred Coleman, for always having the answers to my questions and remembering things I had forgotten. Special thanks go to my daughter, Jennifer, for her constant encouragement and support.

I am grateful to Tammy Strangemann for her enthusiasm and for keeping me organized. My thanks also go to my friends, who were a fountain of information and memories of the "old days." The assistance of Masters Gallery in locating some of my paintings for reproduction in the book was invaluable. The helpful advice and encouragement provided by the Alberta Foundation for the Arts was likewise appreciated.

I am especially indebted to the staff at Fifth House for their professional advice, patience, and many kindnesses, in particular, Charlene Dobmeier, Lesley Reynolds, Liesbeth Leatherbarrow, and Simone Lee.

Introduction

Until I was twelve years old, I lived on a farm near Lloydminster, Alberta. The house was furnished with a few pieces of second-hand furniture—and with love. I had a mother who could make a feast out of wild greens and a father who played Blind Man's Buff with my sisters and me in the evenings—what child could ask for more?

I suppose we were poor, but this was a problem for adults. I had more important things to do: the slough had to be checked constantly for rising or falling water, new growth of bulrushes, the return of water birds and the counting of nests, then the counting of eggs, and after that the counting of young. Patches of lilies of the valley were always interesting because they seemed to just appear and disappear, so they had to be closely watched. Certain trees had to be climbed from time to time, just to see if they were still sturdy, and sitting on the small hill behind the garden and staring at the Blackfoot Hills took up part of each day.

I remember getting up early, before the sun was hot, to pick mushrooms to fry for my breakfast. I would run all the way to the pasture to get them before the one red cow that seemed to share my gourmet tastes. My mother's only comment, as she came in from the barn and found a nine-year-old at the stove stirring mushrooms and inhaling ecstatically, was to ask if I had put the lid back on the butter—we had mice.

I ranged with a little band of friends over our farm and the neighbouring farms, examining, smelling, and feeling anything that caught our interest. Switching from role to role, as our imaginations carried us like strolling players, we moved under fences and down the cow paths. Now we were Robin Hood and his Merry Men, and the spindly poplars were the most solid of oak trees. We turned a rusty binder into a make-believe spaceship and became Buck Rogers and the Professor discovering the space that I read about in the comic strips. In my imagination, I bounded on the moon's surface long before the astronauts took that one small step.

I was the youngest child, so I was at home while my older sisters were at school. My busy farm-wife mother saved every blank piece of paper—calendars, wrapping paper, letters—and put them in front of me, saying "There, draw something for me." At school, drawing made up for my lack of mathematical skills. From a young age, I would look at a picture and think "I can do that." I have a head full of slides that can be brought forward when needed.

When our daughter was born, I wanted to make a record for her of the childhood that shaped me, and I wanted her to see that small, simple, plain farm and love it as I did. But my memory paintings have also become a record for myself. As I work on them, I'm reminded of all the people in my community who looked out for us and cared about us, and who were there to give us a ride to school or help us catch an errant saddle horse.

Through my paintings, I've discovered that almost everyone has a farm in their memory—perhaps their childhood home or a grandparent's or an uncle's farm that stays in their mind. We all seem to cherish that time when we were privileged to be close to the earth.

Spring

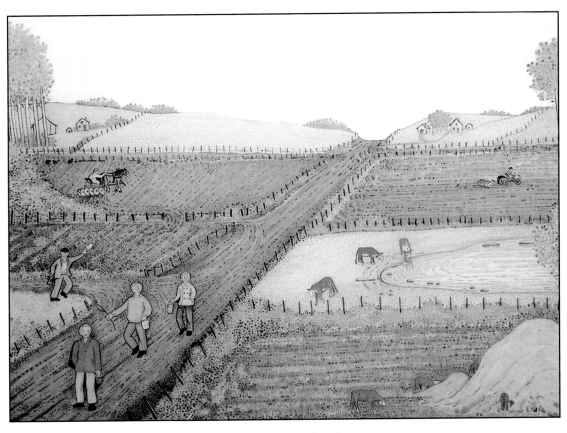

Going to School

The First Nice Day

As soon as the spring sun had dried the ground on the south side of the school, the teacher allowed us to eat lunch outside. Most of the boys were immediately seized with marble madness, and we all thought longingly of the day we could put on runners and play ball.

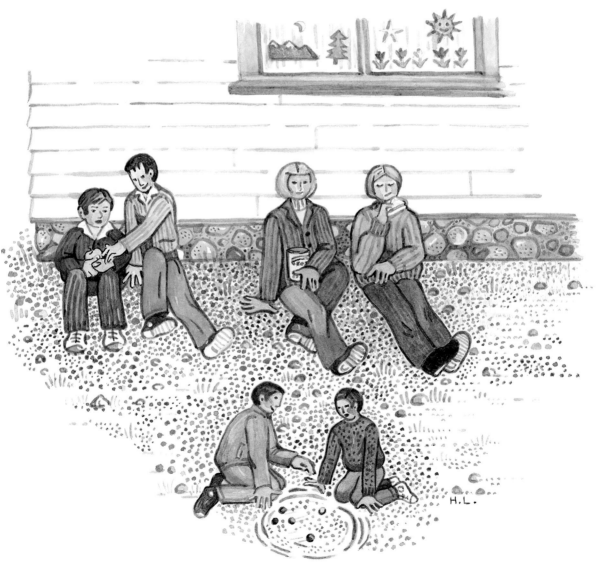

The Blue Heron

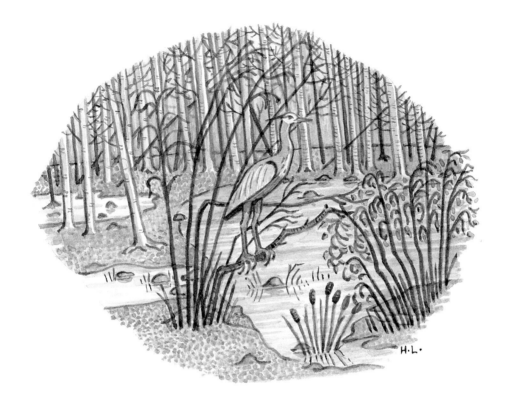

B irds marked the passing of a season as much as the snow melting or the flowers growing. The first "caw" always brought excited cries—"The crows are back!"

One morning, a blue heron stopped at the slough behind our garden, resting on his way to a larger body of water. He soon moved on, but for a day I crouched in the shadows, magically transported to a Louisiana bayou, surrounded by the grunting of alligators and the calls of exotic birds never seen in Alberta.

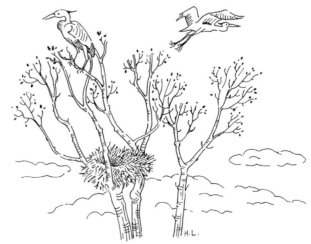

The New Piglets

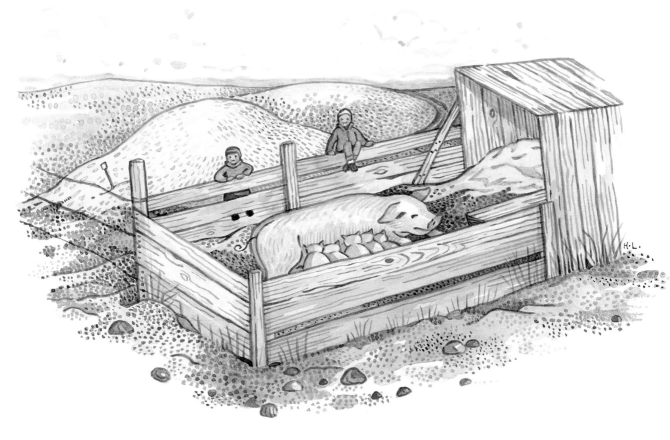

Soft and pink and cuddly, new baby pigs are hard to resist, but their protective 300-pound mama kept us looking but not touching.

When the piglets were very new, my friends and I were not allowed to go near the pen—the mother might kill them if she became excited. We waited for their first "outing," when the weather warmed and the ground dried a little. Then we counted them and named them and watched them grow.

Saturday Shopping in Town

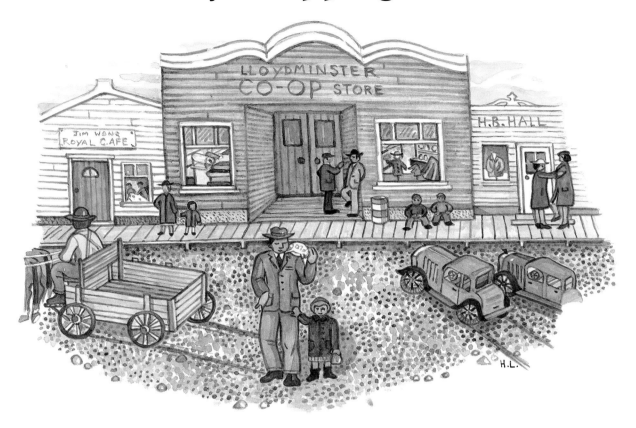

We drove the six miles into town for a few groceries, a machinery part, and, most important, human contact.

Suited and tied, the men stood in small groups discussing the state of the crops and the nation. The women traded recipes, compared the latest egg and butter prices, and assessed the newest project of the Women's Auxiliary.

Once the war began, it took over all the conversations. If someone had a working radio, the latest news was passed on. As the young men left one by one, the war that had been so far away suddenly became a part of our district, and the talk became more anxious.

Miss Marlin's Sugar Bowl

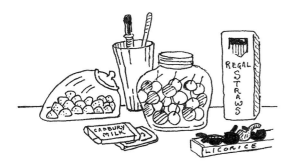

Our town on a Saturday was always interesting to me. One of my favourite places was Miss Marlin's Sugar Bowl, an old-fashioned ice cream parlour and candy shop.

Glass jars filled with candy stood temptingly on the counter. Boxes of chocolates were displayed to inspire anyone looking for a gift. Most of the candies were a penny a piece, or three for a penny, so a child with a nickel was rich.

There really was a five-cent ice cream cone, big and creamy, piled up and running over. And you slurped up drinks through a waxed-paper straw that seldom lasted as long as the soda or milkshake. I never could resist the chewy pink candies that looked like an ice cream cone, or the sugar-covered bright red imitation strawberries.

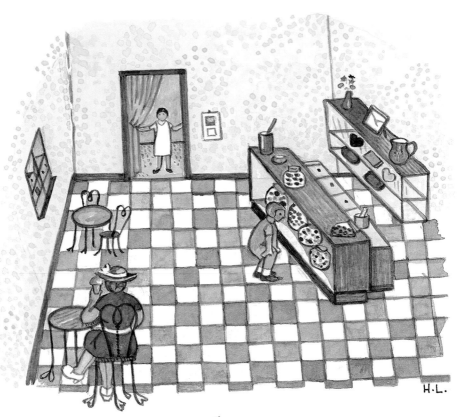

Mr. Nicholas's Butcher Shop

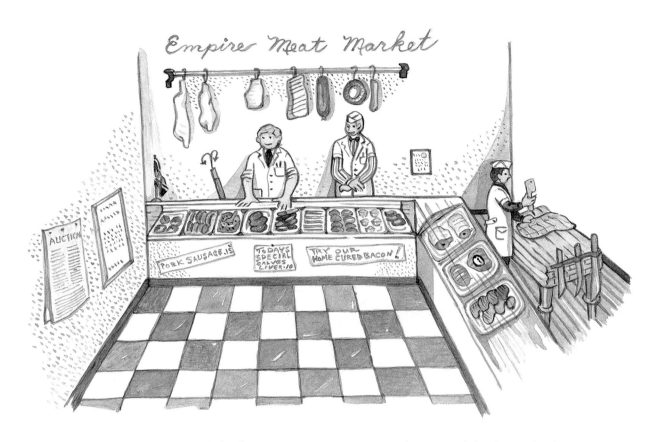

M r. Nicholas's Empire Meat Market was black-and-white and immaculate. He and his two sons were efficient and pleasant. He always gave children a slice of bologna. It was one of the treats of a Saturday in town.

The glossy pink links of sausages made my mouth water. I don't know what secret herbs he used, but his "bangers," as he called them, were delicious.

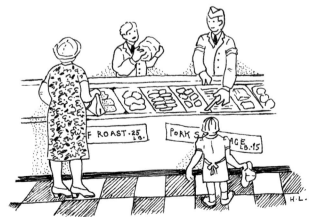

Finding the New Foal

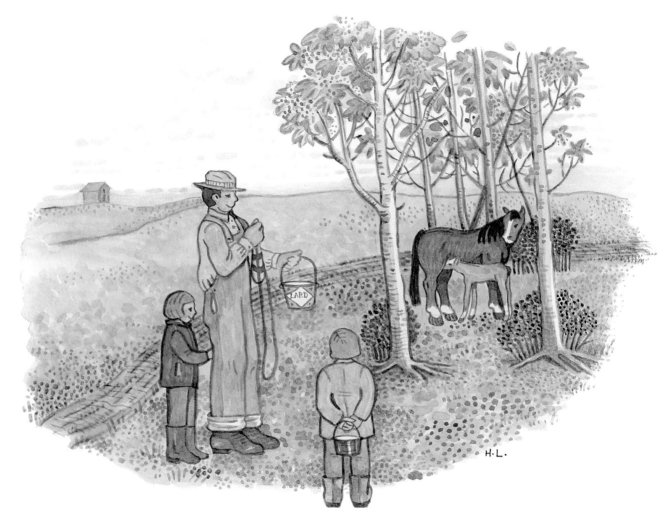

My father always knew when a new foal was expected. When a mare did not appear for her oats with the other horses, he would say, "Come on girls. Help me find her."

Sure enough, there would be the mother standing quietly in the poplar bluff, guarding the new baby. Dad would have a rope halter and a can of oats with him. He'd quickly slip the halter over the horse's head and lead her and the stumbling foal back to the shelter of the barn.

English and French in the Schoolyard

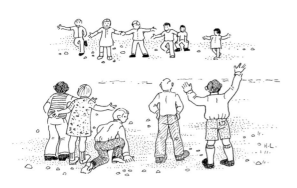

For this game, we lined up facing each other. Two students, "Wolfe" and "Montcalm," stood at a scraped line in the middle. Each side had the same number of sticks behind the line of players. When flags were dropped, we ran at each other and tried to push our way through the other side's line to return with a stick. "Wolfe" and "Montcalm" tried to make sure that everyone followed the rules of the game. At the end of the game, the side with the most sticks won. It was eventually banned from the yard to avoid bloodshed.

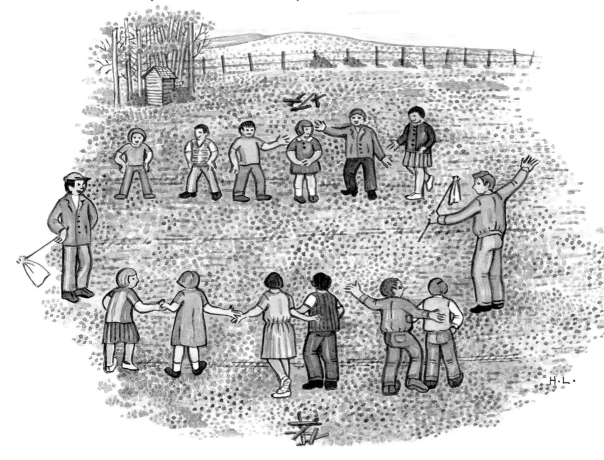

The Old Tool Shed

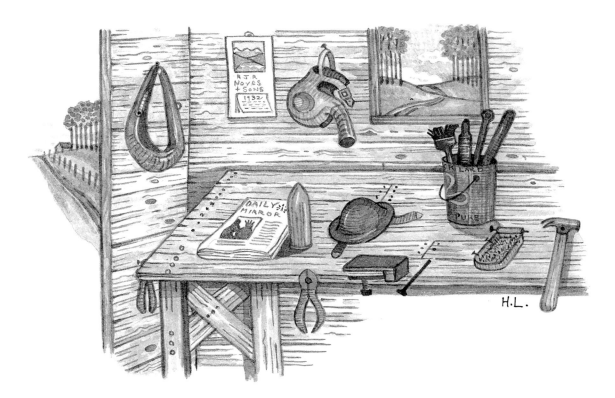

On our farm, if a new barn or tool shed was built, the old building began to fill up with things "too good to throw away."

In our abandoned tool shed, we had a strange collection of memorabilia from the First World War—a gas mask, a helmet, a kit bag, a web belt. We children played with them all, imagining the trenches full of British and Canadian men with shells whizzing overhead. We even had a huge, empty brass shell case, and we fantasized about the sound it would make and how big a hole it would blast in the French countryside.

The Ginseng Hunter

I was amazed when I discovered that we had a plant growing on our farm that was popular in China.

In the spring, one of our neighbours could be seen hunting every pasture for the green-leafed ginseng. His burlap bag bulged with gnarled, man-shaped roots, which he shipped to a Vancouver dealer. One day he scraped a little pulp for me to taste. It had a bitter flavour and I never tried it again.

Ironing Day

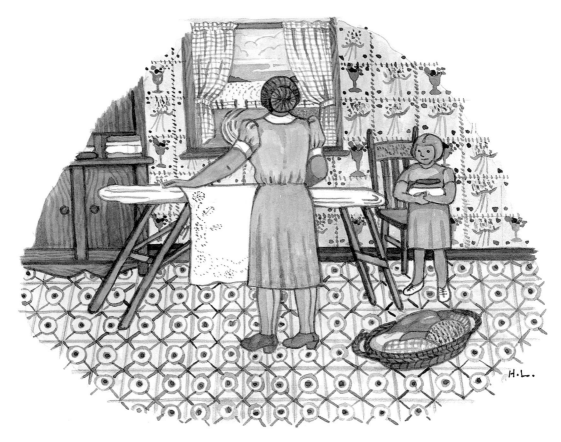

When my mother did the washing, there was no such thing as "wash and wear." Instead, "wash, iron, and wear" was the rule. Everything had to be ironed—only a bachelor wore a wrinkled work shirt.

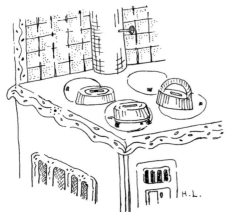

Even if it was a hot day, the stove had to be kept going at top heat for the heavy irons. As chief woodbox engineer, I had to keep enough dry wood on hand to stoke the monster.

My mother made her own starch and sometimes her own soap, but the wonderful smell that rose from the ironing board has never been equalled by any lemon-scented supermarket soap.

Picking Rocks

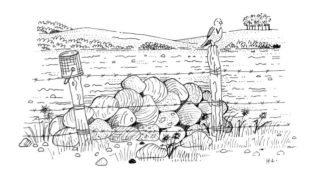

After a piece of land was cleared, it seemed to grow more rocks than crops for a few years.

Patient horses stood quietly while the stoneboat was piled with stones, then the load was dragged to the fenceline and dumped. Weasels and mice, gophers and rabbits eyed the piles as their future homes or at least hiding places from our dog.

Every inch of the field had to be picked clean. If the plow hit a large rock, the plowshare could break, and time was lost going into town to the blacksmith.

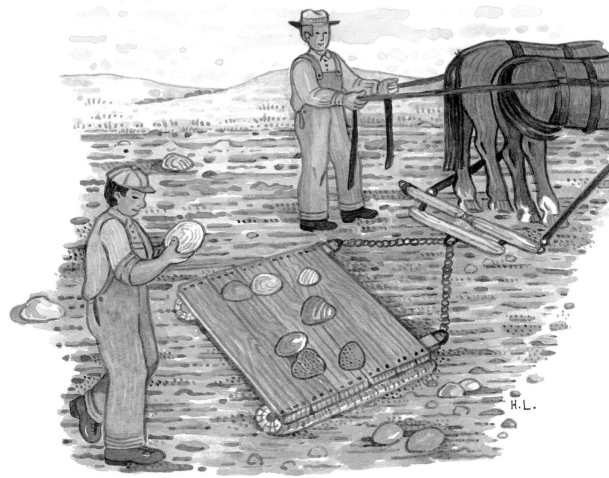

Snaring Gophers

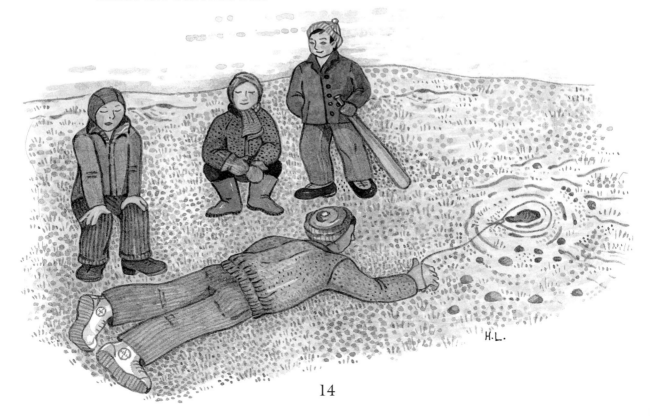

It was a ghastly game and the boys went at it with determination. Gophers were a nuisance. They ate and spoiled grain in the granaries, and their holes tripped saddle horses, often throwing the rider. Besides, the province paid five cents per gopher tail. By the end of summer, a busy boy could easily have one hundred tails.

The supplies were simple: binder twine, a jackknife, a bucket for slough water, a baseball bat, three or four enthusiastic boys, and of course a few gophers.

The "snarer" lay flat on the wet spring ground a few feet from the hole where the gopher was expected to poke out its head. Another boy poured water down the hole that was the secondary entrance. When a confused and wet animal raised its head to look for an escape, the snarer pulled the string quickly and lethally. Gophers have sharp teeth and must be killed quickly— hence the baseball bat.

Run Sheep Run

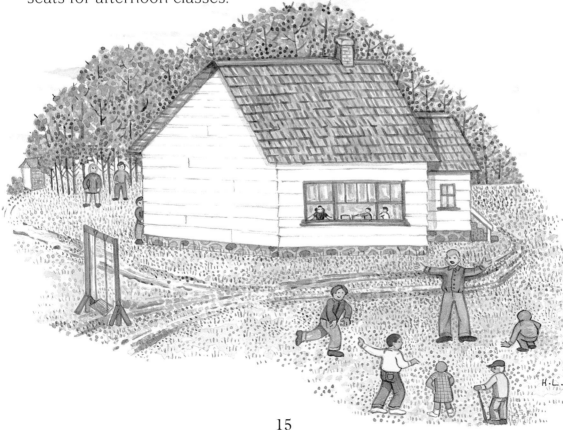

Once the leaves on the trees and bushes were thick enough to hide us, we played noontime games of Run Sheep Run. One person was the shepherd and the leader of the sheep, another was the wolf leader. The wolves looked for the sheep while the shepherd called signals—"warm," "cold," "warmer," "freezing"—to his flock, telling them where the wolves were and throwing the wolves off the trail.

When the shepherd thought the wolf team was far enough away, he yelled "Run Sheep Run!" The hiding sheep then ran for home base—usually a mark on the schoolhouse wall. Any stragglers caught by the wolves were out of the game. A good shepherd kept his flock together until—hot, sweaty, and out of breath—we heard the teacher's bell and ran to our seats for afternoon classes.

The Picnic

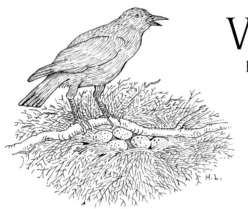

When the dampness left the ground in the spring, picnics were in order. But the lunch itself was unimportant—egg sandwiches, cookies, milk, whatever we could fix from the pantry. The important events were always finding the crows' nests, counting the ducks' eggs, or gathering frogs.

I always thought a picnic would be complete if we could only have Kool-Aid. I had seen the frosty pitcher with the smiling face in an American magazine. I never did taste Kool-Aid until I was grown up.

To me, a picnic still means egg sandwiches.

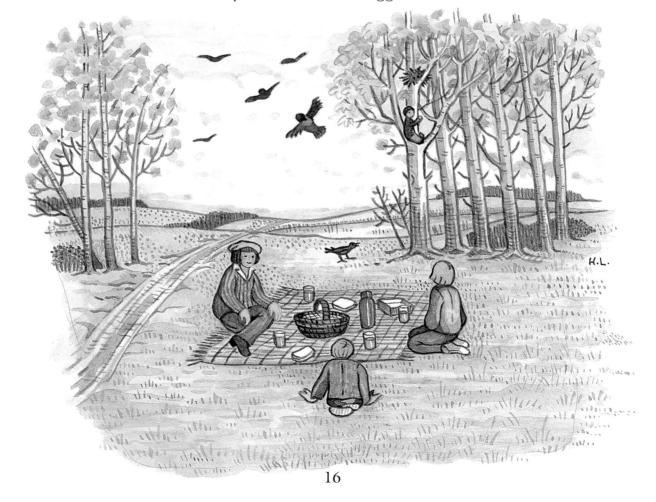

Summer

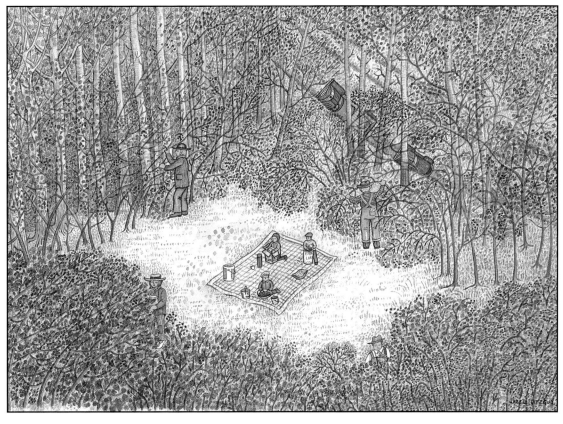

Picking Saskatoons

Parade Day

Red, white, and blue were the colours of the day—it was the anniversary of the coronation of King George V and Queen Mary. My sister Jean was to represent Britannia.

Two grey and shiny Percherons, sleek and prancing in their beribboned harness, pulled the flatbed wagons. We were given buttons and small flags, and neighbours with British roots proudly called out "Jolly Good" and "Up the Empire." The parade queen sat regally (but nervously) in the back of a shiny black truck that was decorated with crepe paper. I think there was a band but maybe I just wanted one.

I thought my sister looked very beautiful, and I hoped someone would buy me an ice cream cone before we went home.

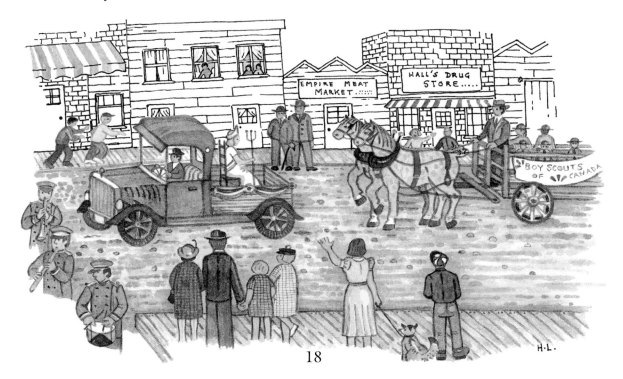

Recess Bell

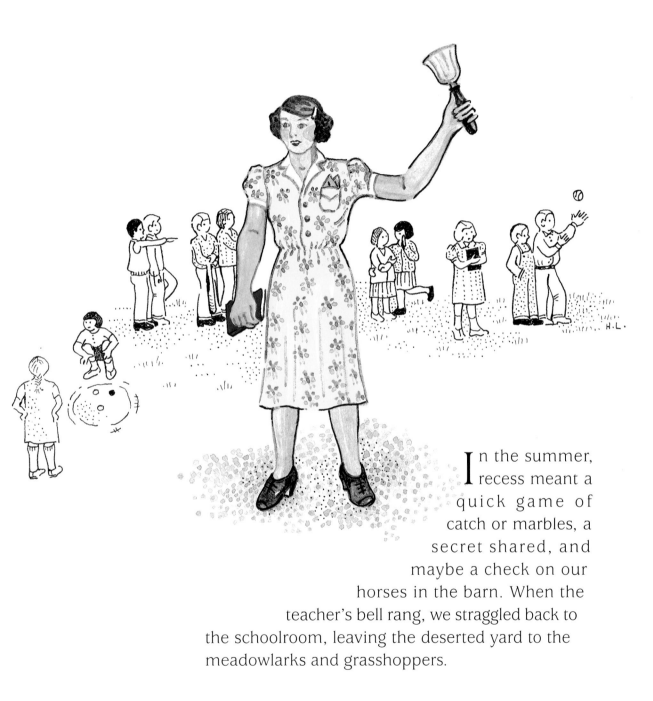

In the summer, recess meant a quick game of catch or marbles, a secret shared, and maybe a check on our horses in the barn. When the teacher's bell rang, we straggled back to the schoolroom, leaving the deserted yard to the meadowlarks and grasshoppers.

The Dugout

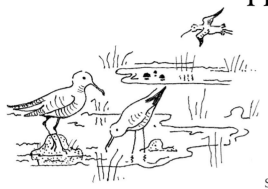

The big slough on our farm usually began to dry up in mid-July, so my father hired a man to build a dugout. It was eight to ten feet deep, and we hoped it would hold water all summer for the cattle to drink.

The clay sides of the little pool were crumbly and slippery, and we never left the house without warnings from my mother to "Stay away from the dugout!"

Needless to say, it fascinated us. When we tired of throwing rocks in the murky water, we collected an endless variety of insects or watched long-legged water birds scramble over the hummocks gathering food for their young families.

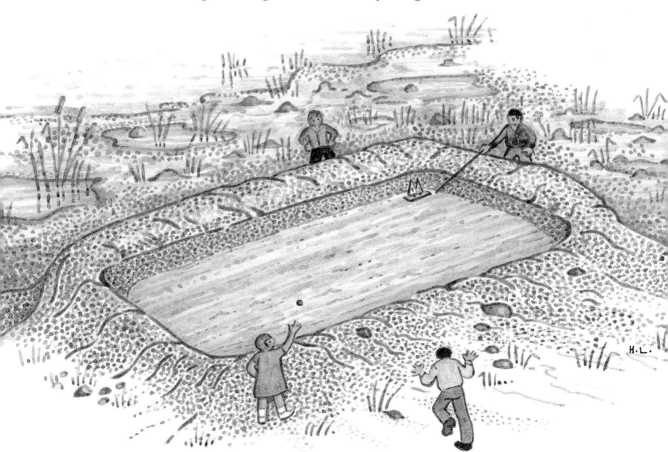

The "Bunty" Calf

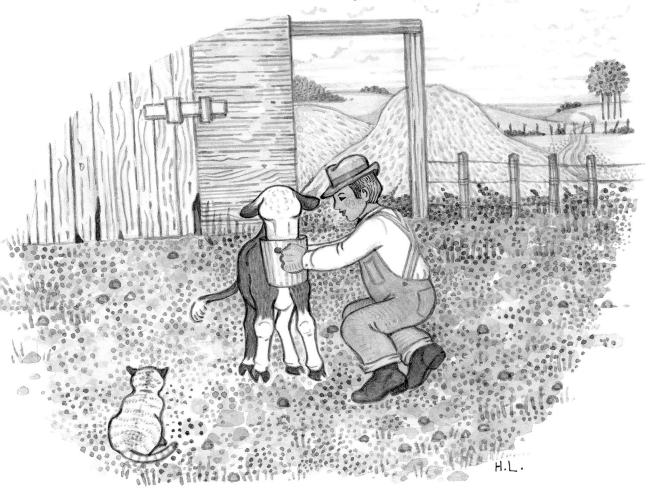

Weaning the calves from their mothers was a job for my father's strong hands. He had to dip two fingers into the milk and let the calf suck on them, gradually coaxing the little "Pail Bunter" to drink. If he wasn't careful, the calf would hit the pail with its head and send the warm milk flying. Later when the calves knew what to do, I was allowed to steady the pail. I liked to pat their rough, curly foreheads while they drank.

Storm Coming

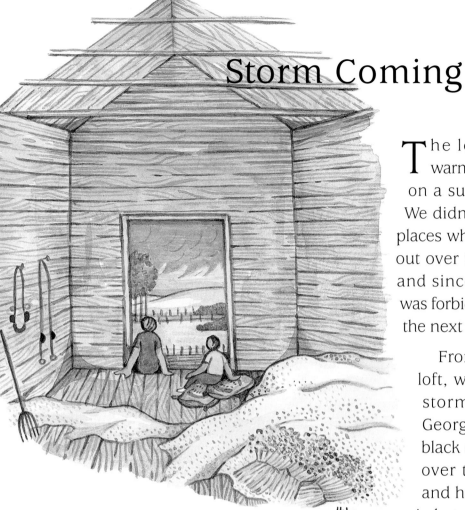

The loft was a dark, warm, mysterious place on a summer afternoon. We didn't have many high places where we could look out over the countryside, and since the barn roof was forbidden, the loft was the next best lookout.

From our perch in the loft, we loved to watch a storm coming over Mr. George's field. The blue-black clouds would sweep over the Blackfoot Hills and hang over the farms in between. There would be a few swirls of dust in the yard. Suddenly the birds would become quiet. A sharp, staccato sound would begin slowly on the roof—Pop! Pop! The big drops would become a roar, and we would watch the hens try to herd their chicks to shelter.

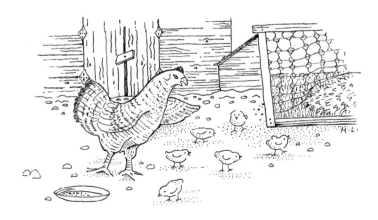

22

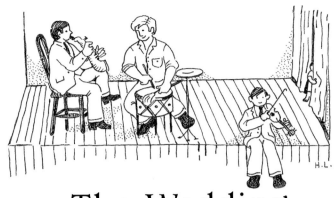

The Wedding

Tables piled with good Ukrainian cooking, a drink of whisky for the men, and a little czarda music—put these together with a bride and groom and you have a wedding celebration that could last for three or four days.

Sometimes a plate was placed on the table beside the bride, and the guests would put gifts of money in it for the couple's new home. The groom was usually expected to show his skill as a dancer, while his new wife looked on and clapped to the faster and faster beat of the little band.

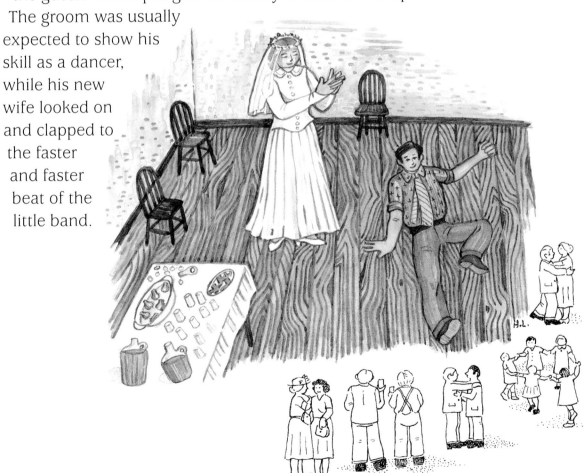

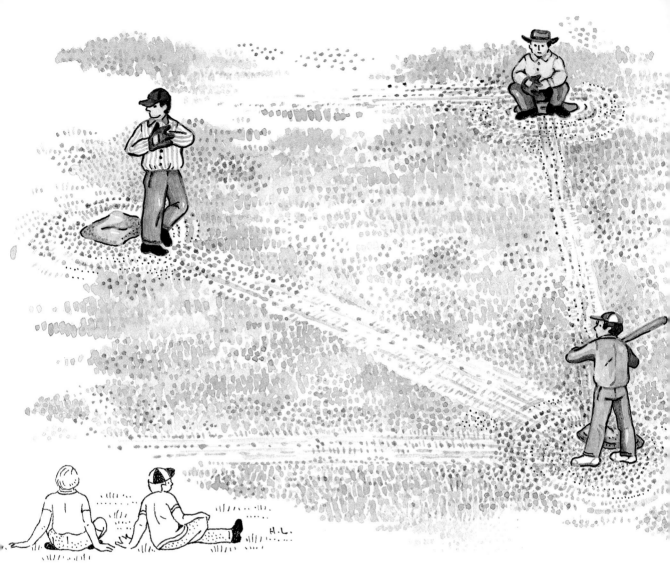

Sunday Baseball

On Sundays, our farm was the gathering place for all ages. As the number of people grew, baseball teams formed. Everybody argued calls, slid into the burlap-bag bases, and desperately tried to hit the much-too-soft softball out of reach.

Anyone who wanted to play was given a place on the field. I always ended up in the outfield, watching the grasshoppers and gophers and hoping the ball wouldn't come my way.

Sunday Afternoon

Softball, sun, and a glass of lemonade under the trees with a neighbour—by July, the hard work in the fields was done and, except for chores, Sunday was a day of some rest.

Boys passing by on horseback joined in the ball game. Maybe a horse was traded, a crochet pattern loaned, or a new recipe introduced. And later there was the click of plates being brought out and put on the table—

"Supper's ready! Finish your game later!" The cows still had to be milked, the chickens shut away, and a little water put on the cabbage plants. The sun went down, friends went home, and the last of the dishes were done by lamplight.

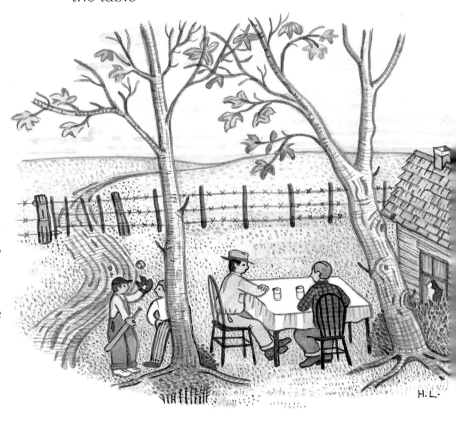

Devonia Lake Picnic

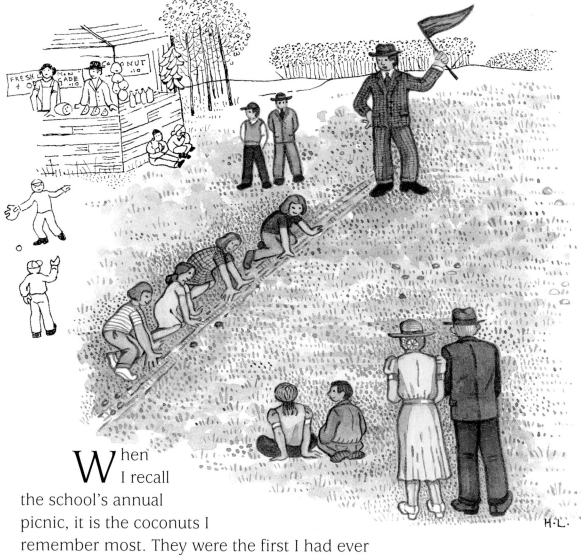

When I recall the school's annual picnic, it is the coconuts I remember most. They were the first I had ever seen, and the milk inside seemed the most wonderful drink.

We had races and ball games, homemade ice cream, and one-cent suckers that really lasted all day. The lemonade and orangeade were made from powders sold by the "Watkins Man."

Simple pleasures from a simpler time.

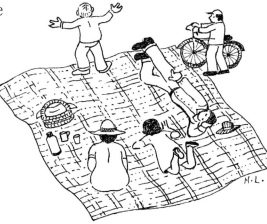

Bread Baking

We consumed a lot of homemade bread, so twice a week my mother set the bread-making process in gear. Mix the dough, let it rise, punch down, rise again, fill the woodbox, and rev up the cookstove. As the first batch went into the oven, a new batch began to rise.

When the bread came out of the oven brown and high, Mother would thump the top with her knuckle. A good hollow "thunk" meant it was done. Then she'd dip a feather in melted butter and run it quickly over the surface to give it a shine and soften the crust.

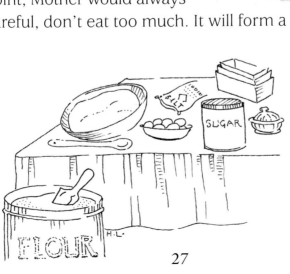

By some instinct, my sisters and I usually appeared about the same time as the finished product for our feast of hot bread and butter and brown sugar. At some point, Mother would always say, "Be careful, don't eat too much. It will form a lump in your stomach."

The Ukrainian Farm

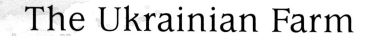

Everything on a Ukrainian farm was used. Starting with very little but their hands, Ukrainian immigrants were able to carve a living out of a piece of Alberta land.

Houses and barns were made from poplar poles chinked with clay, and roofs were usually thatched with straw. As the farmer became more prosperous, the buildings would be whitewashed and the roofs shingled.

The gardens, always abundant, were bright with poppies grown for their seeds and fragrant with dill for the most delicious pickles ever eaten.

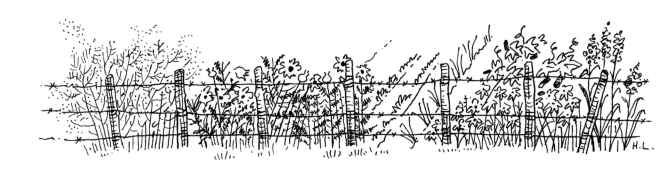

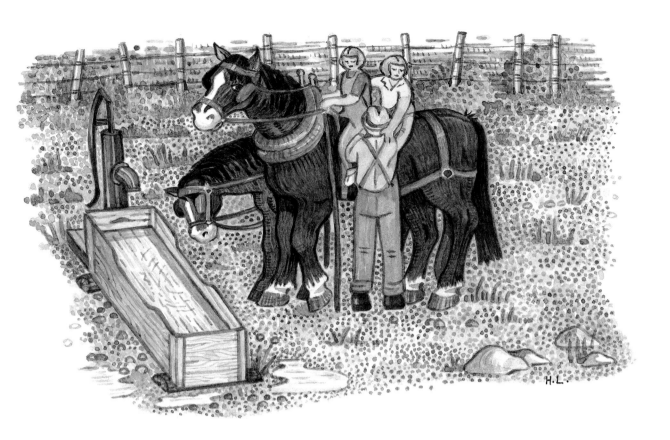

Riding the Blacks

If our timing was good, my sister Milly and I could meet my father as he brought the team home at suppertime. He would lift us onto the cushiony back of one of the blacks and, with him holding the reins and me clutching Milly's waist, we trudged home.

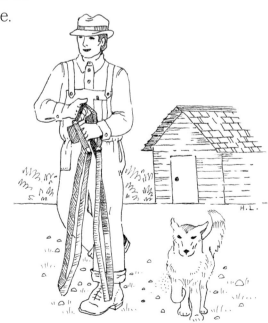

At the water trough, we had to slide off to let the horses drink, their muzzles plunged deep into the cool water and their sides swelling.

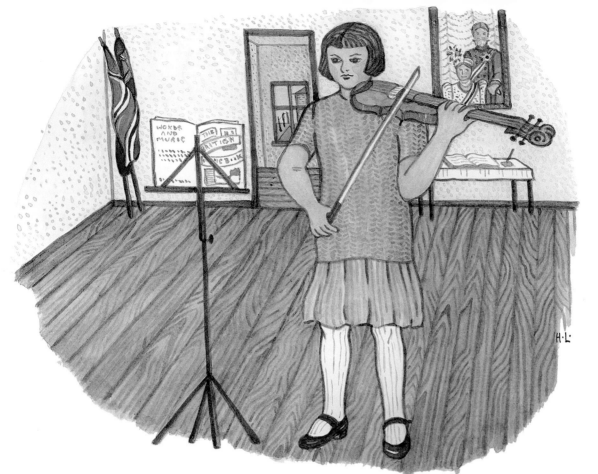

The Violin Lesson

We met once a month in the large, empty room above the town hall. Flags and paraphernalia used by the Elks, Kinsmen, Lions Club, and Legion were stored around the wall, and we were warned not to touch anything. Our bewildered little group stood in a semicircle in front of Mr. Skidnook. Sometimes he would even play for us.

All I remember from my brush with culture is a tune from *Hansel and Gretel* that sometimes hums in my brain along with the composer's name, Engelbert Humperdinck.

Testing the Crop

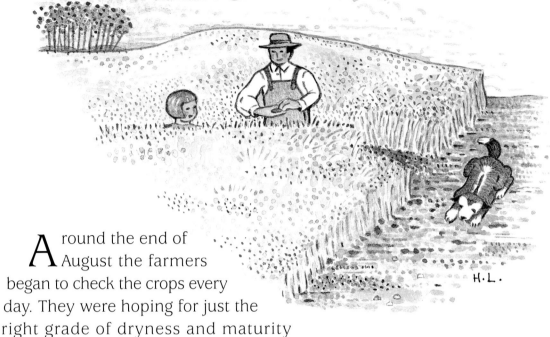

A round the end of August the farmers began to check the crops every day. They were hoping for just the right grade of dryness and maturity before starting to cut.

After supper on a warm evening, we would walk out to the field and wait while Dad stripped off a handful of heads of grain and rolled the kernels in his hands. "Too doughy" meant a day or two to wait and pray for sun. "Just right" signalled that the busy harvest time was about to begin.

The World's Tiniest Couple

Once, at the Lloydminster Fair, my friend Howard and I saw two people billed as the world's tiniest couple. We were amazed by these perfectly formed, doll-like people. For days after, we wondered what their house looked like and how they coped with the giant world around them.

I can still remember the song they sang, "That's the story of, that's the glory of love."

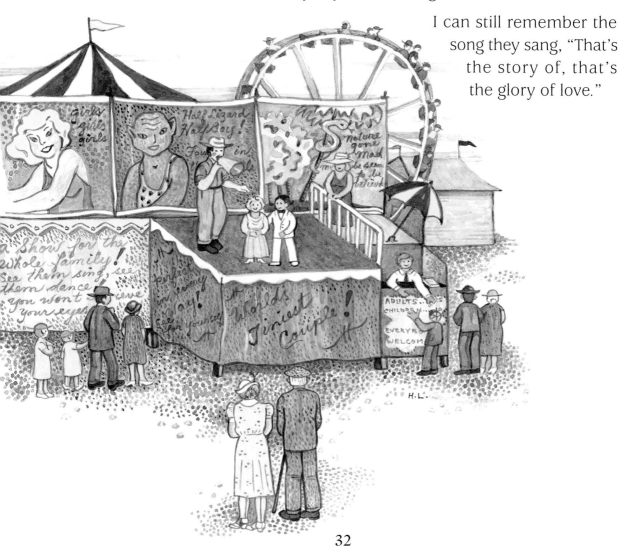

Fall

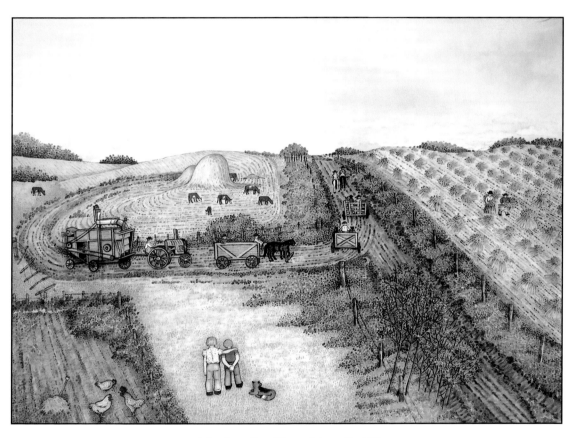

Moving the Threshing Outfit

Taking Up the Garden

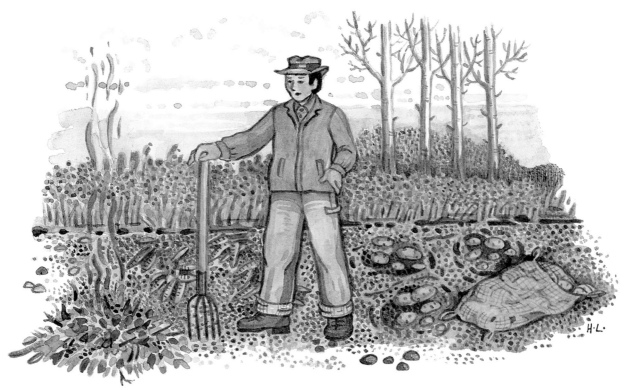

The air would have a tang of fall, the leaves yellowing a little, and my mother would say, "I think we'll start taking up the garden tomorrow."

Carrots were dug and wiped free of dirt, turnips the same. The tops were twisted off and put aside for the pigs. The corn stalks were chopped down and put in a pile to burn.

No farm home could have too many potatoes, so row after row was dug and put in burlap bags. Down they would go into the cool, moist cellar under the kitchen. Beady-eyed mice watched all this, hardly believing their good fortune of the feasts to come.

Late Milking

Fall work often kept my father late in the field, so the chores had to be done by lantern. The yellow circle of light bobbed back and forth across the yard, from building to building, as he and his dog checked and fed the animals and closed everything against nightly intruders.

When the milking was done, they turned toward the house. "Here they come!" I would announce from my post at the window, and I'd hear Mother putting the kettle on the hot stove lid.

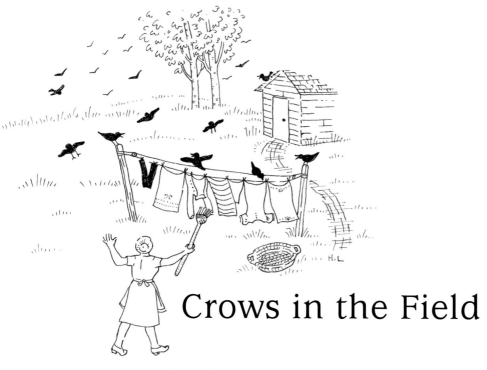

Crows in the Field

Suddenly in the fall, the sky was full of the harsh cawing of a black cloud of crows. They swooped into our yard, jostling one another on fences and telephone wires. What were they shouting? Was it a crow version of an election? Were they deciding when they would head south and who would lead them? Save your energy for the journey, I thought.

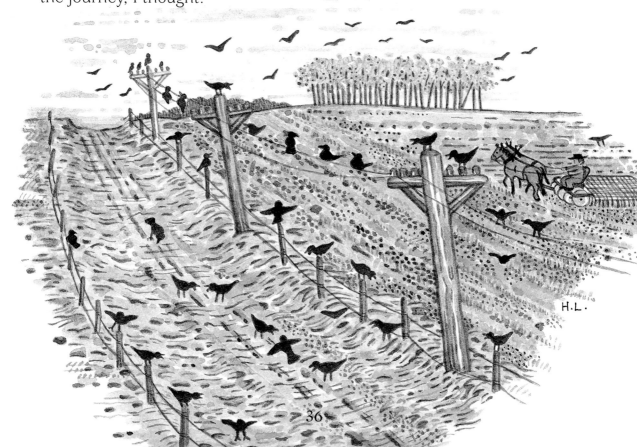

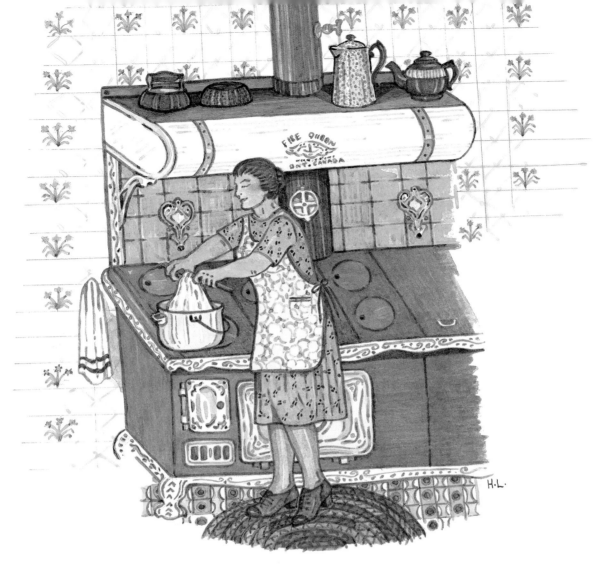

Canning Peaches

When the fruit came into the stores in the fall, my mother canned every day until a winter's supply had been put in the cellar. My sister Milly and I helped, sorting lids for the small jars or rubbing the skins off the scalded peaches. Sometimes we found a leaf in the case of fruit. We would turn it over in our hands and wonder what such wonderful trees must look like.

The Cellar

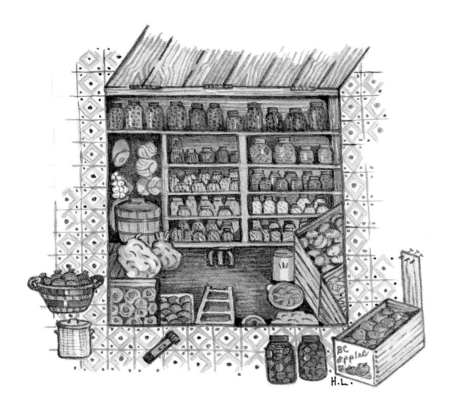

Dark, damp, musty smelling—the cellar was not my favourite place. By October, all the vegetables were tucked into their sand-filled bins and burlap bags. Pickles were salted down in crocks and eggs were floated in isinglass.

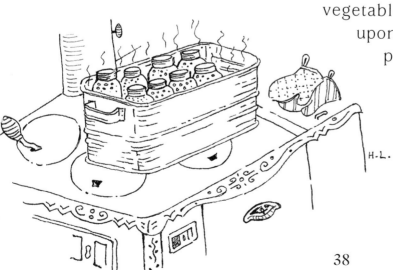

My mother's canned fruits and vegetables stood gleaming row upon row. Each sealer was a picture of the preserver's care. If any discolouration developed, that jar went out immediately. No housewife wanted an explosion of glass and juice to clean up.

The Threshing Crew

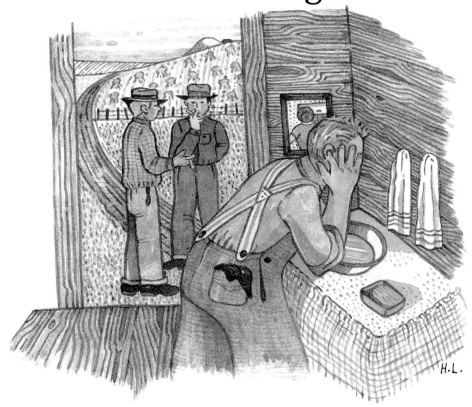

They came from Manitoba, Ontario, and Saskatchewan. Some were neighbour boys. All of them wanted to earn a few dollars and get away from home. And, unless they were new to harvesting, they all knew they would work hard from sun-up to sundown.

Some had worked for my father before and came in on a freight car with a bedding roll and not much else. They laughed a lot, teased my sister and me, and played tricks on one another. But in the field, they worked like fiends. A slacker was shunned by the other men and he soon moved on.

My father seldom had to fire anyone. Most knew the rules—no fighting, no drinking, and definitely no smoking in the barn or near the threshing outfit. Fire was always on everyone's mind. The sloughs and wells were low in the fall, and no fire truck came roaring to the rescue in our district.

Cooking for the Threshers

My mother was what she called "a good plain cook," and the threshers' enthusiasm for the meals at our house was evident. If a farm wife did not "set a good table," word spread and it was difficult to find a threshing crew to take off the crop.

I'm still amazed by the enormous amount of food polished off by those hard-working men. My older sisters and I helped Mother and the hired girl prepare three gargantuan feasts every day until the crop was in the granaries.

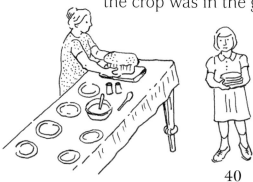

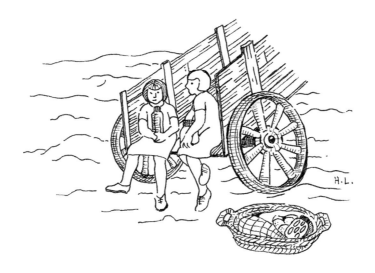

Taking the Lunch to the Field

My sister Milly and I were so proud when we were old enough to take the noon meal to the threshers in the field. We'd put stacks of roast beef sandwiches and apple pie, baked that morning, into a big wicker laundry basket. Then, one on each handle, we trudged toward the noise and dust of the outfit.

The men were black with dirt and oil and were usually exhausted from their 5 a.m. start. I wondered if they noticed the neatly ironed linen that covered their lunch.

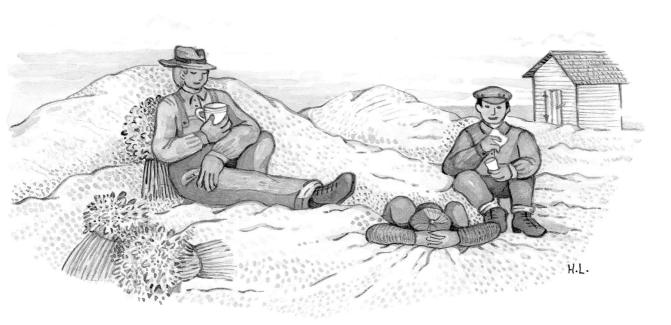

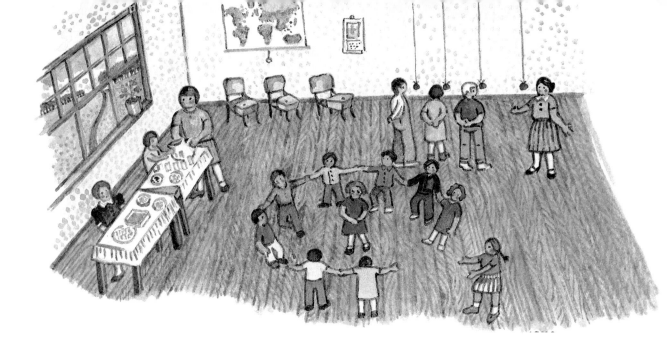

Halloween Party

On Halloween, studies stopped at one o'clock at Westminster Park School. Tubs of water were brought in for apple bobbing. Several apples were hung from the ceiling on strings and two children, hands behind their backs, would try to take bites out of the same apple. This game almost always involved a boy and a girl—and much teasing from their friends.

The older children organized the games of Farmer in the Dell and Musical Chairs. If there were any costumes, they were homemade, as was the lunch—from sandwiches and dill pickles to candy.

Cloud Pictures

My friend Howard and I could spend hours watching clouds change shape. Whales swallowed up dragons that became sailing ships. The variations were endless. Only the hardness of the ground and waiting chores sent us running down the hill toward home.

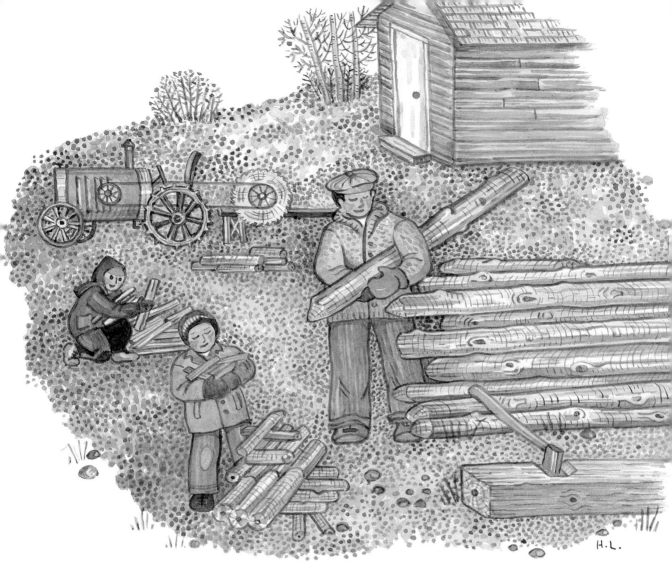

Putting Up the Winter Wood

In the fall, the whine of a wood saw carried for miles in the quiet, chilly air, as farmers prepared their winter fuel supply. It was a slow process. The poplar trees had to be cut and piled in the yard with branches trimmed, then sawed to a good stove length. Later, it took many days to split the wood with an axe and move it closer to the house. I had the job of moving the sticks away from the saw and into a pile beside the chopping block.

44

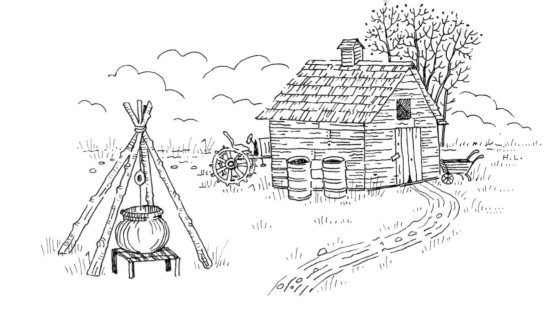

Scalding the Pig

Every fall, each farmer butchered a pig to supply some of the winter meat for the table. The joke about everything being used but the squeal was almost true—all parts had some use. After the roasts, chops, spare ribs, and sausage meat were cut, the pork fat was boiled down and strained to make fine white lard for baking. The feet and head were boiled for headcheese, and the offal was thrown to the dogs, sitting expectantly on the fringe of the action.

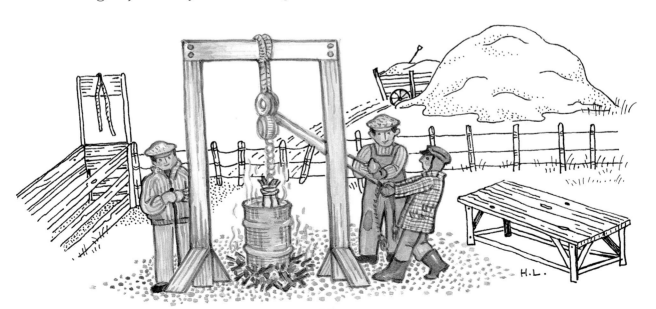

Making-over

E very house had a clothing box,
and each season the making-over
of clothes began. If any part of a
garment could be salvaged, my
mother set it aside. It would turn
up later as sleeves, or a vest,
or a collar and cuffs on a
party dress. Any piece of
fur was treasured and
moved from coat to coat
down the line of children.

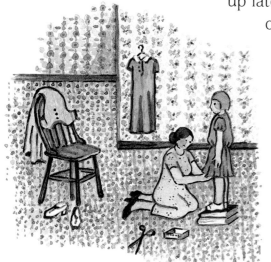

The Blackfoot Hills

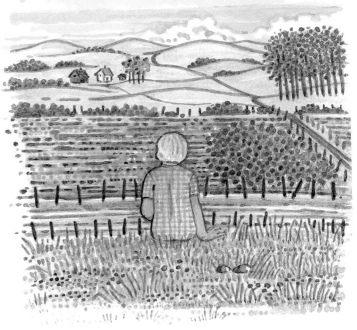

From the ridge behind our house, the Blackfoot Hills were always a tantalizing crooked line against the horizon. Did the Blackfoot people still camp in their dark shadows? Was that line of smoke a campfire or just burning brush?

Once we went into the hills to pick blueberries. That day, every tree seemed to have a shadowy figure behind it. As we drove away, tom-toms struck up a rhythm behind the next ridge, but my father said it was only a prairie chicken drumming on a log.

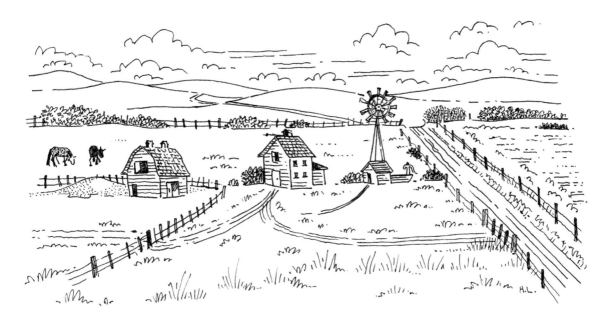

47

The Box Social

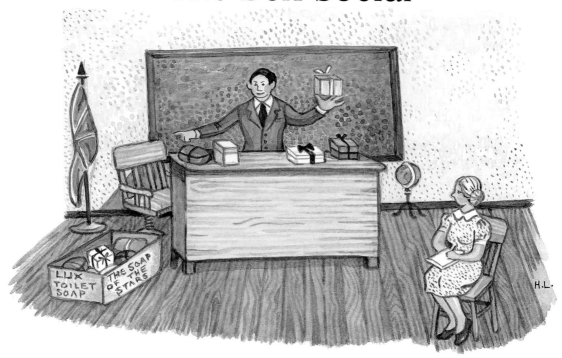

Once a year, each district held a box social as a fundraiser. It was a good reason for a get-together for people who lived several miles apart and didn't visit often.

Each woman packed a tasty lunch of sandwiches or cold chicken and a special cake or cookies. She decorated her box with bows and ribbon, sometimes in a unique way so a knowledgeable admirer would be sure to bid on it.

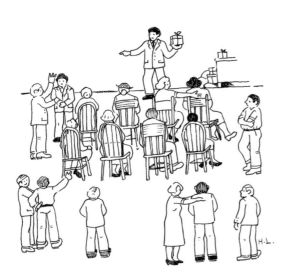

When a man bought a box, he had the right to eat with the woman who made it. There was much teasing and baiting of the bidders as the men spent their scarce and hard-earned dollars to impress the lady of their choice.

Winter

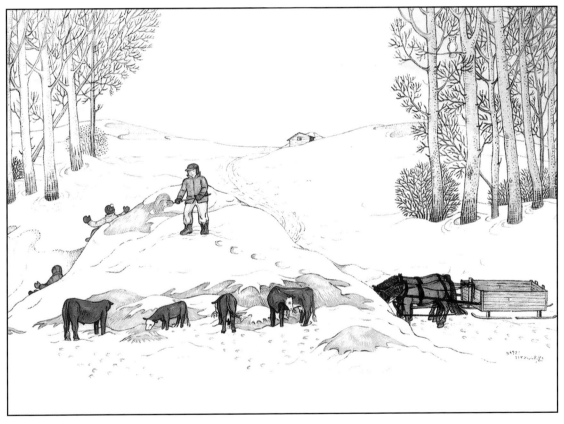

Putting Down Straw for the Cattle

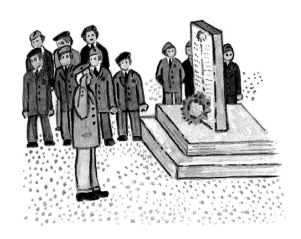

Armistice Day

In my memory, November 11 is always a cold, grey day with a skiff of snow on the bare ground. Just before eleven o'clock, the men in the Reserve would gather at the war memorial.

I knew that some of the men standing around the cenotaph had been in the Boer War and the First World War, and I would watch their faces, trying to read their thoughts during the two minutes of silence.

What I could not know was that many of them were to lose sons in the new war that was just beginning.

Mending Harness

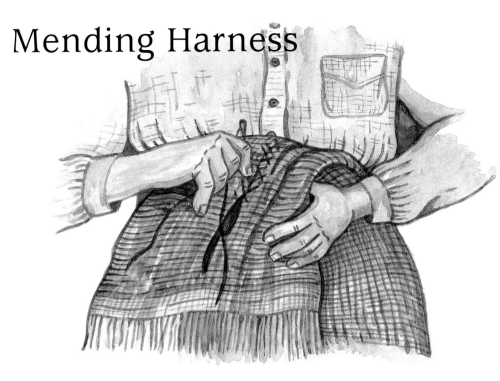

Winter months were a good time to do catch-up work that there was no time to do in the summer. A farmer had to be his own blacksmith, mechanic, and veterinarian. There was no running into town for a small repair job. My father would bring in armfuls of stiff harness gear and lay it out in the kitchen. While it warmed, the room filled with the lovely smell of leather, harness oil, and horses, which was not always appreciated by my mother. My father could mend a saddle blanket as neatly as my mother could mend a sock, but I never saw her repair a saddle blanket, nor him darn a sock.

51

Going to the Neighbours

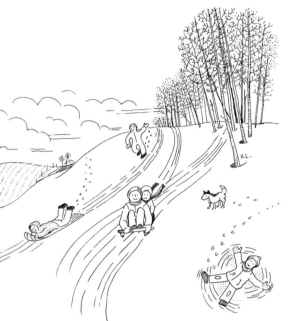

There was a hill behind our house that seemed to belong to us children alone. It was our short-cut, our meeting place, and our lookout. In the summer a meadowlark nested there, but in the winter it was a scene of frantic activity as we slid down the hill on cardboard, sleigh, or toboggan.

Halfway up the path was a place where the trees met overhead even in winter. Our house was hidden from view, and the sky was shut out by the hilltop. The quietness of the spot always sent me running for the crest of the hill and sight of the road to the neighbours' house.

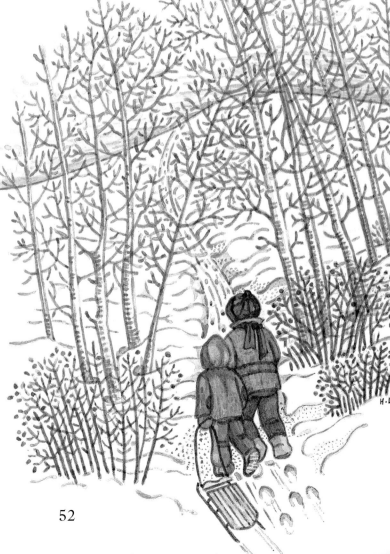

Running on the Drifts

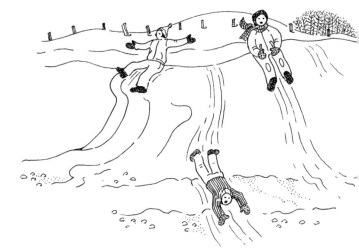

After an all-night snow and wind storm, we could run all the way to school on top of the crusty drifts. Along the way, we'd play King of the Castle and slither down the slopes in our moccasins. Sleighs and cars had to wait for the road grader to come through. Then we had marvellously steep cliffs to climb. Sometimes we could look down on the horses' backs as they trotted by.

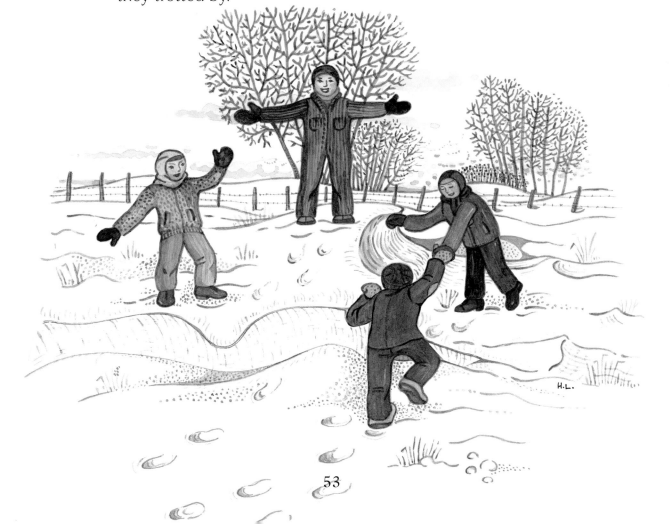

Lunch at School

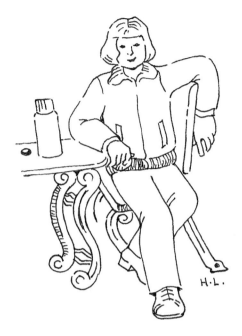

The bigger boys in grades eight and nine brought in the wood and kept the fire stoked. Still, those at the front of the room shivered while those at the back roasted.

At noon, we would pull our chairs around the pot-bellied heater and toast our feet and talk—well, the older kids talked. Sometimes we all played I Spy or told riddles. If we had planned ahead, we brought soup in a Rogers Syrup pail and heated it on the stove. To avoid an explosion, it was important to loosen the lid.

All afternoon, we lived with the smell of singed moccasins.

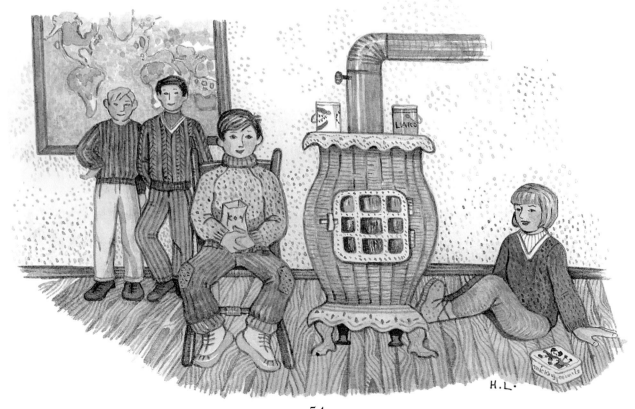

Breaking
the Ice in the
Water Trough

Until the ice in the water trough became too thick to chop, Father broke it open each day so the cattle could drink. As soon as they heard the thunk-thunk of the axe, the animals would gather and jostle each other around the pump. My father always favoured one old milk cow and allowed her to drink first, which she did with great dignity.

55

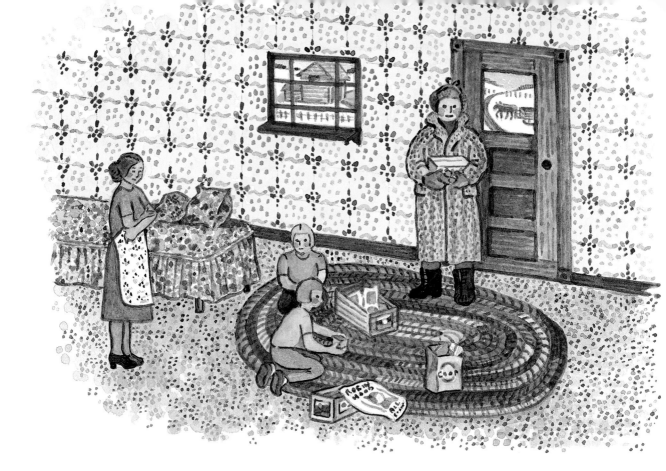

Christmas Oranges

A ll year long, the taste of Christmas oranges lingered on my tongue.

Such treasures from a country so far away might as well have come from another planet—so marvellous was their arrival. We examined the label on the box, smelled the rough, slivery wood, and then unwrapped the crinkly, orange tissue paper and tasted the fruit.

Now the Christmas excitement had begun.

The Christmas Concert

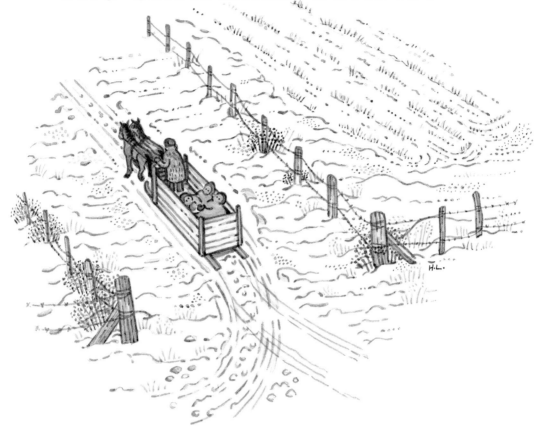

The Christmas concert was absolutely the best time of year. For weeks before the big night, we practised our lines, tried on crepe-paper costumes, and wondered what would be under the tree for us.

Every child performed in the concert, and there were often tears and forgotten lines. Santa's arrival was the high point of the evening. Each child got a bag of candy, an orange, and a present. Lunch was served, the adults visited, and we ran and played until we were exhausted.

On the way home, we snuggled under the buffalo robe and counted the stars. Coyotes shrilled somewhere in the dark hills, and we slowly fell asleep to the jingle of the harness.

The Prairie Nativity

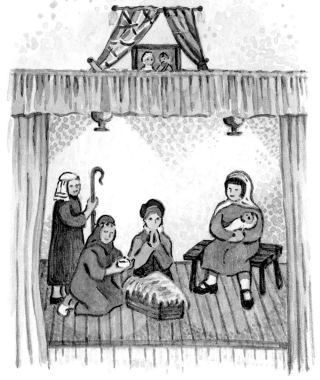

Every Christmas concert ended with a nativity scene.

The solemn moment often became hilarious when one of the wise men tripped on the robe of the shy wise man in front of him, or perhaps because Mary kept her chewing gum in action.

Mary's part called for rounded cheeks and plump arms, so I never got that role. However, one year my doll was chosen to be the baby Jesus—only to be forgotten by an absent-minded Mary. At the moment the baby was to be presented, Mary rushed offstage past three confused wise men, returning with the miracle child they had come to see.

Skating on Devonia Lake

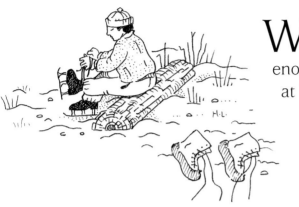

When the wind blew the lake free of snow, and when the ice was thick enough, children from all around gathered at Mr. George's farm with their skates.

Once you've sailed down a lake with the wind at your back, not stopping until everyone is far behind, you will never think of gliding around a rink as really skating.

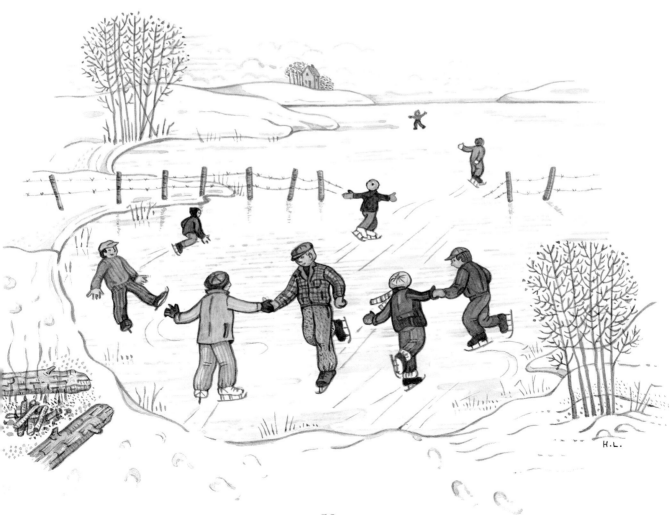

Digging Out

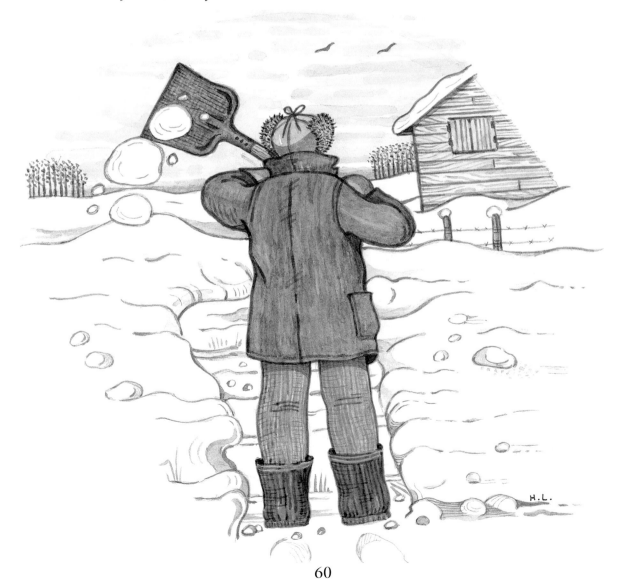

After a big snowstorm,
everyone spent the
next few days digging out: first,
the path to the barn so my father
could check on the animals, next,
the path to the "little house" out back.
We knew that there would be a scolding if
we had left the shovel out in the yard and not on
the porch, ready for action.

A Schottische

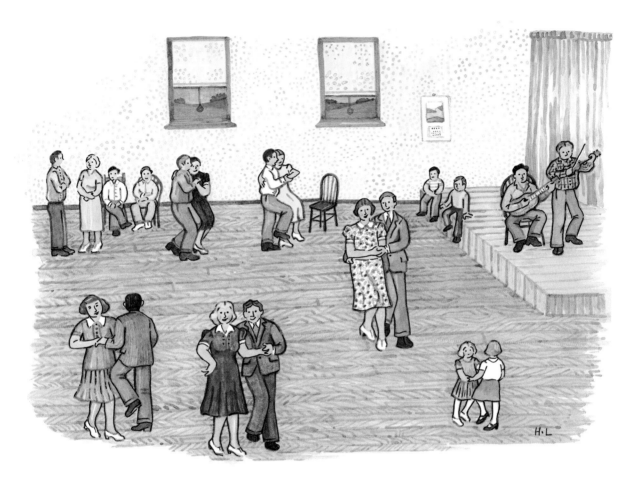

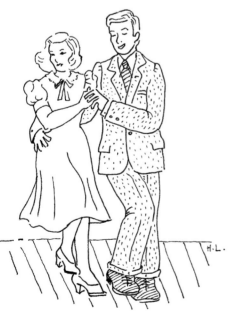

A guitar, a violin, and a piano would bang out the music for our Friday night dances. For the polka and the schottische, the idea seemed to be to get everyone going as fast as possible so the floor shook and cheeks flamed. Afterwards, all the women had to go to the cloakroom to replace hairpins sent flying through the air.

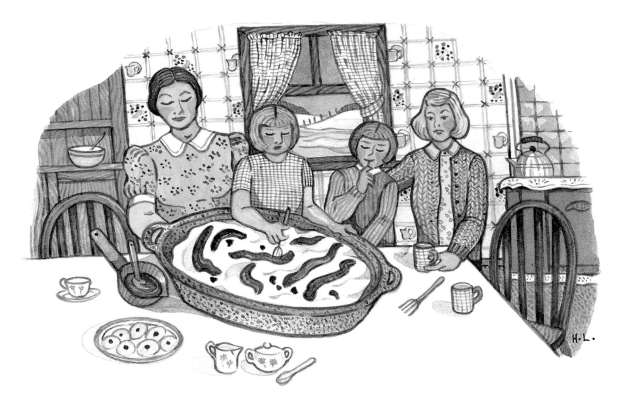

Snow Taffy

Mother didn't believe in a lot of sweets, so candy was a rarity at our house. But on cold winter nights, she would sometimes treat us with snow taffy. It couldn't have been simpler, but what excitement!

Dad would pack the dishpan with clean snow. Meanwhile, my mother would boil maple-flavoured syrup on the stove. When it reached the threading stage, it would be dribbled over the snow, where it instantly hardened. Then we would wind up a mouthful of taffy with a fork and gorge ourselves until bedtime.

The Toy Box

Our toy box was full of broken contraptions, games with pieces missing, tired books and animals, odd sizes of crayons, and colouring books that always seemed to be fully coloured—maybe that's why I began to draw my own pictures.

One Christmas I received a rubber-stamp printing set and I decided to start a newspaper. The project never got underway, probably because of a shortage of both news and paper.

My sisters and I didn't play with anything much. After all, we had woods full of life and a barnyard of intriguing animals that moved on their own. We used to empty everything out of the box, look at it, and then get on with some creative activity in the great world outside. If the weather was nice, we stayed inside only long enough to eat. If the weather was bad, blankets and chairs made playhouses and tunnels. Who needed toys?

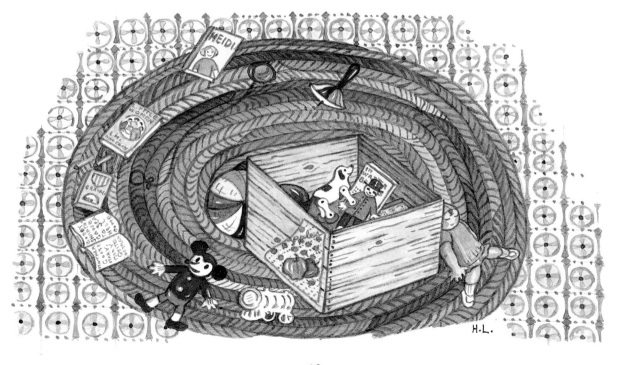

Hockey Night in Canada

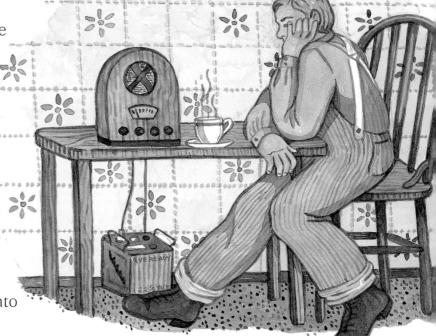

Lionel and Charlie Conacher, Red Horner, Syl Apps, Howie Morenz. "He shoots! He scores!" Those names and that phrase crackled in and out on our radio on a winter night, bringing a rush of excitement into our prairie farmhouse.

My father sat near the speaker, lost to the game swirling up and down a brightly lit rink in far-away Toronto or Montreal. As the battery waned, Foster Hewitt's shrill voice described a scene so alive that it's still more real to me than any TV broadcast.

Everyone expected the Conacher brothers to get in a fight. They seldom disappointed us, and we all waited in agony while they sat out their penalties.

Mother tut-tutted impatiently at every fracas and frequently pointed out that it was "after all, only a game." It *was* only a game, true, but for two hours on a Saturday night, Canada wasn't just a huge country blanketed in snow. It became an icy battle-ground filled with life, energy, and young men having the time of their lives and ours.

Glossary

Apple bobbing: A game usually played at Halloween where participants use their mouths to grab apples floating in a tub of water.

Armistice Day: November 11, the day when war veterans are remembered, now called Remembrance Day.

Bedding roll: Blankets and a pillow tied up for travel, similar to a sleeping bag.

Binder: A machine used to tie bundles of hay, called sheaves.

Binder twine: The coarse string used to tie sheaves of hay.

Blacksmith: A person who works with iron.

Blind Man's Buff: A children's game where one of the participants is blindfolded and tries to catch the other players.

Boer War: The South African war (1899–1902) between Britain and the Afrikaners, who were Dutch settlers in South Africa.

Britannia: The female symbol of Britain.

Buffalo robe: A heavy robe made of buffalo hide.

Bunty: A word used to describe an animal that pushes or butts something.

Burlap: A coarse canvas made of jute or hemp, often used to make potato sacks.

Cenotaph: A memorial to those who died at war.

Chinked: Filled with a material such as clay to prevent drafts, especially the spaces between poles or logs used to construct the walls of buildings.

Crochet: To make yarn into a lacy fabric with a small hooked rod.

Crock: A ceramic container used to store food, such as pickles.

Czarda: A lively dance from Hungary.

Darn: To mend with wool, particularly socks.

Elks: A men's club.

English and French: A children's game based on the Battle of the Plains of Abraham in 1759 at Quebec City.

Flatbed wagon: A wagon with the sides removed.

Gas mask: A mask used to protect soldiers from poisonous gases.

Granary: A small building used to store grain.

Hairpin: A metal pin used to fasten hair in place.

Halter: A noose, cord, strap, or headgear used to lead or tie up a horse.

Headcheese: A meat mixture.

Hired girl: A young woman who works on the farm for wages.

Hummock: A knobby hump of ground in a field.

Isinglass: A liquid used to preserve eggs.

Jackknife: A small folding knife with several blades.

Kinsmen: A men's club.

Kit bag: A large duffel bag used to carry soldier's equipment or travel gear.

Legion: A club for war veterans.

Lions Club: A men's club.

Little house: An outdoor toilet, also called an outhouse.

Nativity: The festival of the birth of Christ.

Offal: The internal organs from an animal carcass.

Pantry: A small room off the kitchen usually used for storing food.

Percheron: A breed of heavy draft horse, originally from France.

Plow: A piece of farm equipment used to break or plow land.

Plowshare: A sharp blade on a plow used to cut the earth for planting.

Polka: A lively dance from Bohemia, in central Europe.

Pot-bellied heater: A round heater fuelled by wood or coal.

Preserve: To can or freeze food to prevent it from spoiling.

Reserve: An armed force, trained and kept in reserve for emergencies or war.

Road grader: A large machine with a blade in the front used to level rough roads.

Run Sheep Run: A game where one team of children, the "sheep," hide from another team, the "wolves."

Salt down: To preserve food in salt.

Scald: To pour boiling liquid over something.

Schottische: A Scottish dance.

Sealer: A glass jar used to preserve food.

Shell: A hollow metal case that contains explosives and is fired from a gun or mortar.

Snare: A string loop made to catch animals.

Stoke: To feed, stir up, or poke a fire.

Stoneboat: A large, flat-bottomed sled used to haul stones off fields.

Stove lid: The round lid on a wood stove.

Thatch: To cover a roof in layers of straw or hay.

Thresh: To separate the grain from the straw.

Tom-tom: A small, hand-beaten drum.

Watkins Man: A salesman who drove around the countryside selling Watkins products.

Web belt: A soldier's stiff, fabric belt that sometimes held gun cartridges.

Women's Auxiliary: A women's organization.

Index

About the Author

Hazel Litzgus was born and raised near Lloydminster, Alberta. She is a largely self-taught artist whose best-loved paintings are detailed portrayals of small-town life, farm work, and children at play. Drawn from memory, her watercolours are executed in a simple style that includes the distortions of perspective found in naïve or primitive painting. Her art has been featured in many Canadian exhibitions and is included in a large number of private and corporate collections. Litzgus resides in Calgary, Alberta.